• A BEGINNER'S GUIDE •

lettering

and

→ MODERN ←

calligraphy

EMAIL US AT

paperpeonypress@gmail.com

TO GET FREE GOODIES!

Just title the email "Free Goodies Please!"

And we'll send some extra surprises your way!

✗ TABLE OF CONTENTS ✗

GETTING STARTED

Terminology, Technique, Tools, & Tips

LET'S START AT THE VERY BEGINNING

Alright, you creative geniuses, let's get started! First, let's look at the four T's in this introduction to lettering: terminology, technique, tools, & tips. I know you are anxious to dive in and flip to the fun projects, but lettering is a skill that is truly built based on practice! First, let's get familiar with a few basic lettering terms.

TERMINOLOGY

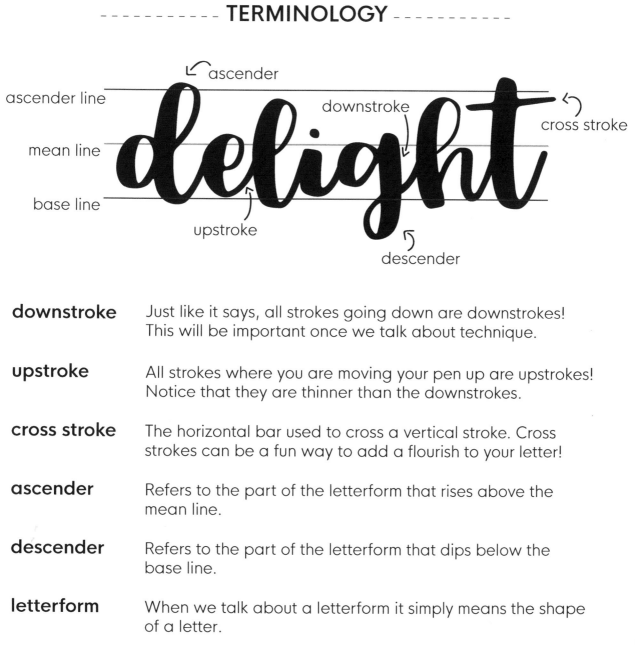

downstroke	Just like it says, all strokes going down are downstrokes! This will be important once we talk about technique.
upstroke	All strokes where you are moving your pen up are upstrokes! Notice that they are thinner than the downstrokes.
cross stroke	The horizontal bar used to cross a vertical stroke. Cross strokes can be a fun way to add a flourish to your letter!
ascender	Refers to the part of the letterform that rises above the mean line.
descender	Refers to the part of the letterform that dips below the base line.
letterform	When we talk about a letterform it simply means the shape of a letter.

Now let's look at the classifications of type.

script —————• Script is a fluid style of lettering that mimics the look of calligraphy or cursive. Typically, the letters are all connected and flow together.

SERIF —————• Serif refers to the small bar at the top and bottom of each stroke in a letter. This style is widely used because it is said to be the easiest style to read.

SANS SERIF —————• The word "sans" means "without" in French, therefore, you'll notice this style does not have bars attached to the letterforms.

In this book we'll practice all three types of lettering with a series of letter guides, practice words, and projects! But for now, the two terms you should focus on are downstrokes and upstrokes. Typically in script lettering, down-strokes are thicker than upstrokes. Thicker downstrokes can be created in two different ways. We'll discuss this on the next page as we dive into technique!

practice =MAKES= *progress*

TECHNIQUE

• BRUSH LETTERING, HAND LETTERING, & CALLIGRAPHY •

What's the difference?! Traditional calligraphy is a beautiful form of penmanship created by using special instruments - a dip pen with a nib and ink. Traditional calligraphy has a strict set of rules in regards to strokes and formation. As calligraphy has become increasingly popular, modern calligraphy has emerged. With modern calligraphy, you can bend the rules to create different strokes and formations while also using different mediums. In this book, we'll be learning modern calligraphy! Brush lettering is a style of lettering that looks like it was created with...a brush! To create this style of lettering, a brush pen or an actual paint brush is used. In brush lettering, you use different degrees of pressure to create thicker or thinner strokes. Hand lettering is often defined as the art of drawing letters, as opposed to writing them. With hand lettering you do not use pressure to create thicker or thinner strokes, instead you simply draw in thicker downstrokes. Sometimes hand lettering is referred to as "faux calligraphy" because of this. The fun part of hand lettering is that you can use almost any medium to write with! Let's chat a bit about the two different techniques.

BRUSH LETTERING

As we mentioned, a brush pen or an actual paintbrush is used to create this style. To get thick downstrokes, hold your pen at a 45 degree angle and apply hard pressure as you create your downstrokes. As you move your pen into your upstrokes, simply lighten the pressure while continuing to hold your pen at that 45 degree angle. You'll notice that the tip of the pen flexes againt the paper as you push down, which in turn creates those thicker downstrokes!

downstrokes are created with hard pressure

upstrokes are created with light pressure

HAND LETTERING

The beauty of hand lettering is that you can use any writing utencil! The sky's the limit! Instead of using pressure to create thick downstrokes, you just draw them in!

1. Write your word. 2. Outline downstrokes. 3. Fill downstrokes!

TOOLS

One of the most exciting parts of lettering is exploring the many mediums you can use to create modern calligraphy! Let's look at some supplies you'll need.

- **PENCILS**

 Grab a good pencil, preferably one with harder lead, to create the first draft or sketch for all of your lettering desings. You'll also need a good eraser to go with it! We prefer a good mechanical pencil and the Mono eraser.

- **PENS**

 After you've created your first draft in pencil, if you are hand lettering, you can ink over it with a pen! There are so many great pen options out there. Micron Pens come in a variety of sizes and are great, high quality lettering pens. Sharpies and gel pens are also a fun medium to try!

- **BRUSH PENS**

 Felt tipped brush pens are made specifically for brush lettering and will flex against the paper when pressure is applied to create thicker or thinner strokes. The Tombow Dual Brush Pen is a favorite amongst the hand lettering community!

- **MARKERS**

 You can buy an inexpensive set of Crayolas or a higher priced set of alcohol markers to flex those hand lettering skills! Spectrum Noir alcohol markers are a great, high quality marker set, but we also love a good Crayola!

- **WATERCOLOR**

 Watercolors provide a beautiful tool for lettering! Watercolor lettering comes with its own set of challenges but watercolors are very forgiving and allow for easy blending.

- **COLORED PENCILS**

 Colored pencils present a fun opportunity to add pops of color in upexpected ways to your lettering! Shade your letters in different colors or add colorful flourishes. Prismacolor pencils are top of the line!

- **CHALK**

 Chalk lettering is a such a unique medium as you can really create depth to your lettering by using chalk dust to enhance the shadows! The black and white contrast is really eye catching!

Remember!

ONE - - - - - - - - -
The most important tip is to write slowly! Think of lettering as drawing each letter, instead of just writing each letter.

TWO - - - - - - - - -
Start with pencil. You can draw and erase as you fine tune your letters!

THREE - - - - - - - -
Pick up your pen in between strokes. Unlike cursive, where your pen flows on the paper through the entire word, lettering is made up of multiple strokes.

FOUR - - - - - - - - -
As mentioned, in calligraphy downstrokes are always thicker.

FIVE - - - - - - - - -
Upstrokes are always thinner.

SIX - - - - - - - - -
Practice! Master your letterforms first! Then master connecting those letters as you write full words. Once you have mastered connections, practice your composition and design!

practice, practice, practice!

In the next section we will begin to draw our letterforms! Get those pencils, pens, and brush pens ready! Your lettering journey begins!

let's do this!

LETTER GUIDES

Script, Serif, & Sans Serif

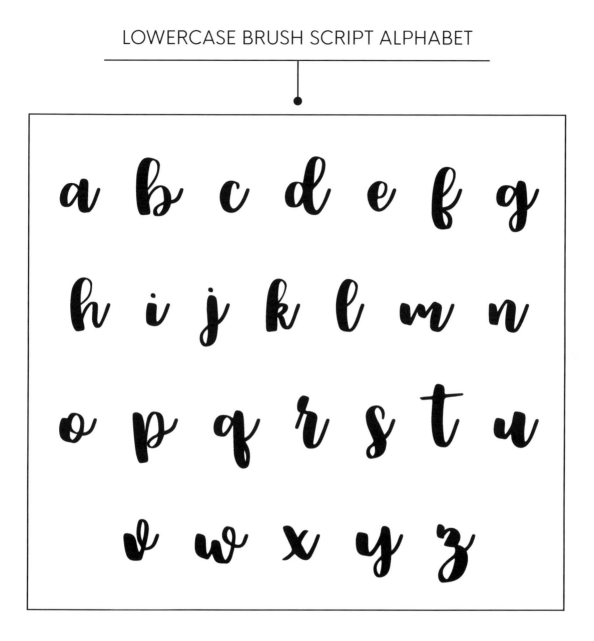

GET OUT YOUR BRUSH PENS!

Our first practice guide is a brush lettering alphabet! Before you dive into the exercise on the next page, first get out a blank scrap paper and play around with your brush pen. Make some circles, swirls, upstrokes, and downstrokes, and pay attention to how the pen reacts to varying degrees of pressure. Once you feel comfortable, start practicing your letterforms!

a a a

b b b

c c c

d d d

e e e

f f f

g g g

h h h

i *i* *i*

j *j* *j*

k *k* *k*

l *l* *l*

m *m* *m*

n *n* *n*

o *o* *o*

p *p* *p*

q q q

r r r

s s s

t t t

u u u

v v v

w w w

x x x

y *y* *y*

z *z* *z*

A B C D E F G

H I J K L M N

O P Q R S T U

V W X Y Z

KEEP ON BRUSHIN' ON!

Our next practice guide introduces the uppercase brush script alphabet! Are you more comfortable with the feel of the brush? With every practice session, your muscles will begin to memorize the motions you take to draw each letter. Remember to take your time with each letter and keep practicing!

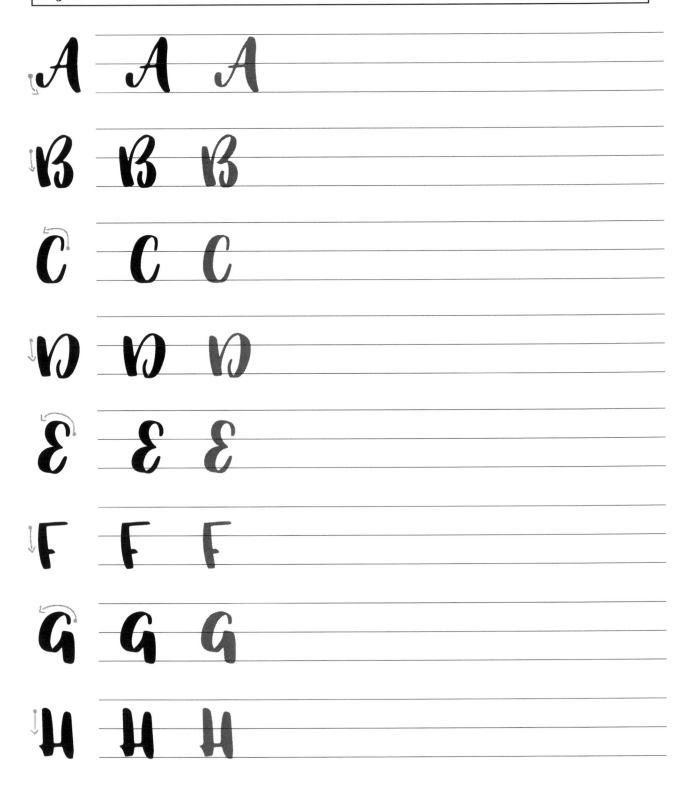

I see you rockin' this alphabet.

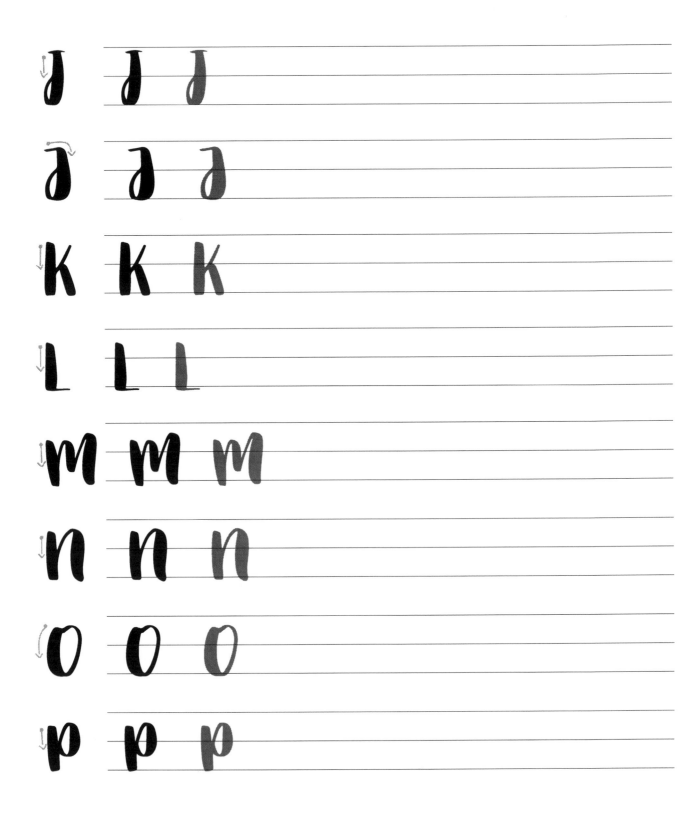

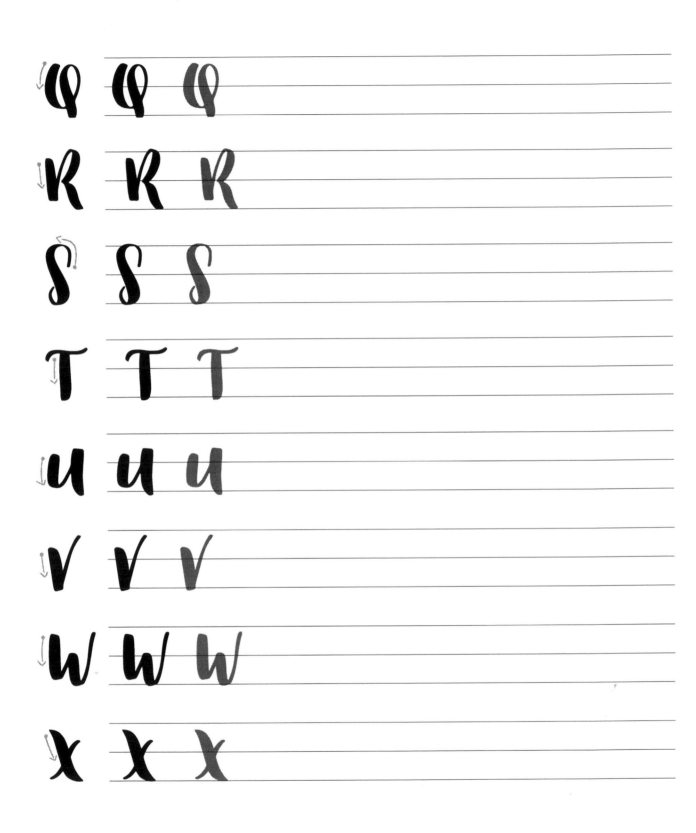

y *y* *y*

z *z* *z*

a b c d e f g

h i j k l m n

o p q r s t u

v w x y z

ONE STYLE TWO WAYS!

Our next practice guide introduces a fun hand lettering alphabet! The unique part of this alphabet is you have the choice as to whether you want to make the downstrokes thick or leave them thin! The examples on the next page show the letterforms with thin strokes, however, if you want, you can simply outline the downstrokes and fill them in! Remember, for this alphabet you can use any type of pencil or pen! (We'll get back to those brush pens later so put them away for now!)

a a a

b b b

c c c

d d d

e e e

f f f

g g g

h h h

Just keep lettering, just keep lettering!

i i i

j j j

k k k

ℓ ℓ ℓ

m m m

n n n

o o o

p p p

q q q

r r r

8 8 8

t t t

u u u

v v v

w w w

x x x

y y y

z z z

A B C D E F G

H I J K L M N

O P Q R S T U

V W X Y Z

THICK OR THIN?

Let's take a shot at the uppercase hand lettering alphabet! This alphabet is so beautiful, it is a great lettering style for so many projects. After completing the lowercase alphabet, do you prefer thick or thin strokes with this alphabet?! I know, sometimes it's hard to choose! But it's nice that you can easily transform this alphabet just by creating thicker down-strokes if you want to! Keep practicing, friend! You are doing GREAT!

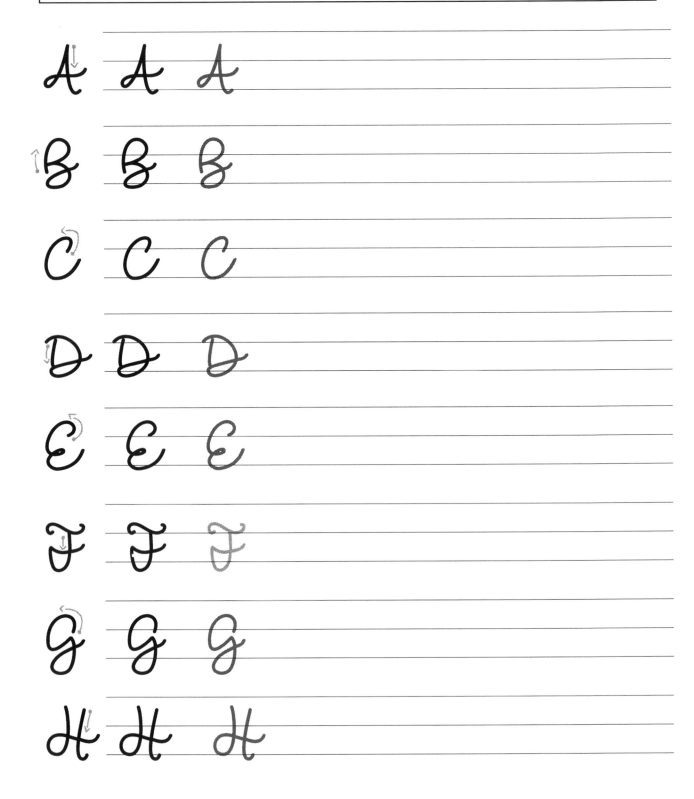

You are da bomb! Keep practicing!

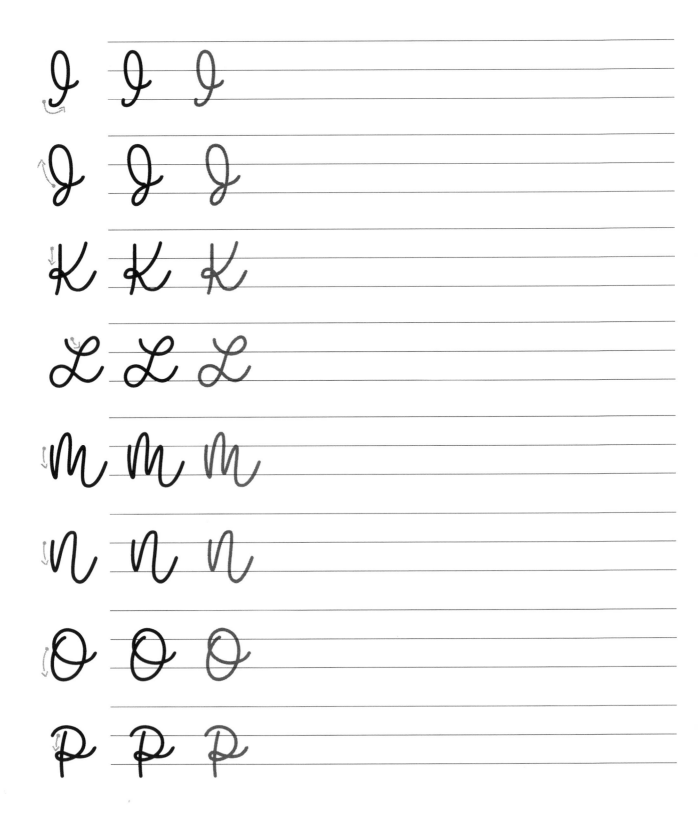

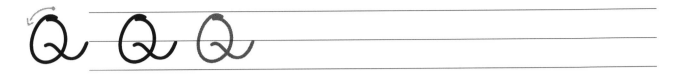

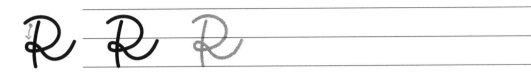

Y Y Y

Z Z Z

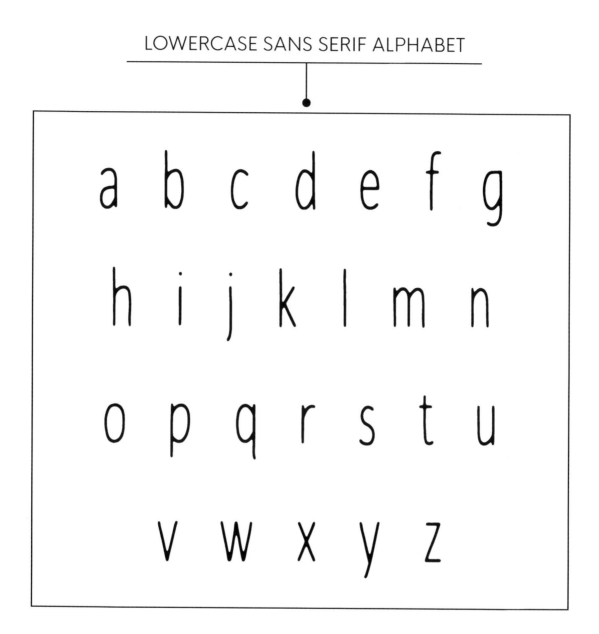

MIX AND MATCH!

Our next practice guide introduces the first lettering style that you can mix and match with your script fonts! It can stand on it's own, but it is also a great style to mix with the more fluid lettering styles to provide contrast and visual interest. This lowercase sans serif is a style that you probably feel much more familiar with as it closely resembles regular handwriting, but don't be fooled! To get those precise lines and perfect curves, it still takes practice and muscle memory!

a a a

b b b

c c c

d d d

e e e

f f f

g g g

h h h

Ooh!! You're on fire!

i i i

j j j

k k k

l l l

m m m

n n n

o o o

p p p

q q q

r r r

s s s

t t t

u u u

v v v

w w w

x x x

y y y

z z z

A B C D E F G
H I J K L M N
O P Q R S T U
V W X Y Z

BIG "A" LITTLE "a"!

Our next practice guide covers the uppercase sans serif alphabet. As you begin to develop your own style of lettering and design, you may notice that you always gravitate towards lowercase letters, or, vice versa, maybe you prefer uppercase! The more you practice your letters, the easier it will become to recreate when you move on to writing words and phrases!

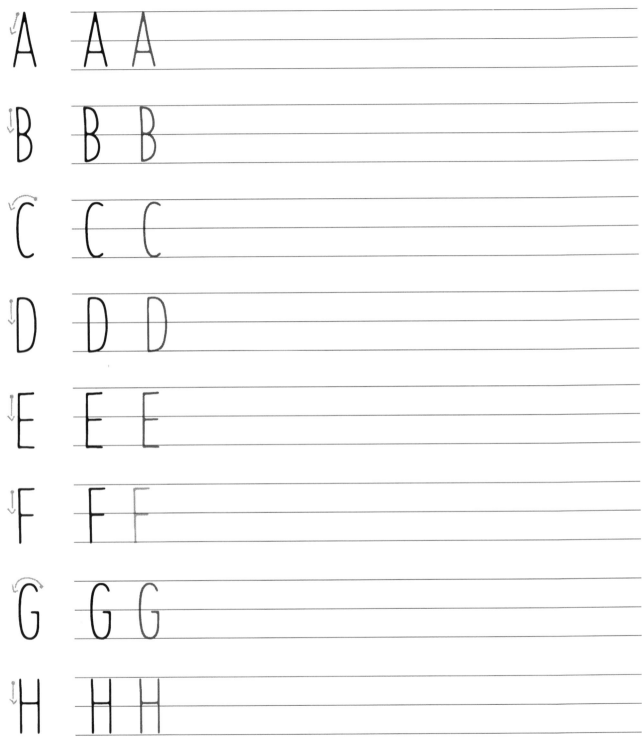

Go on with your bad self!

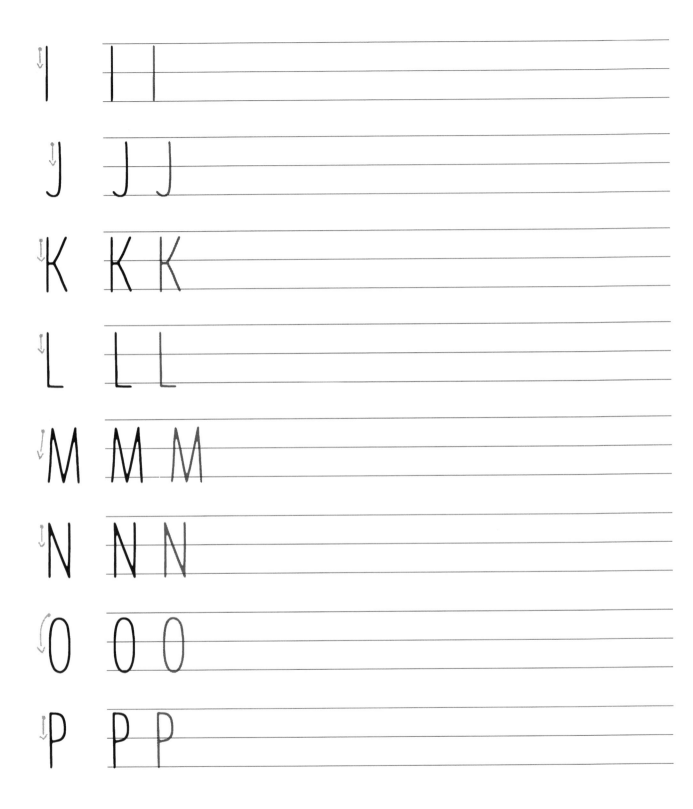

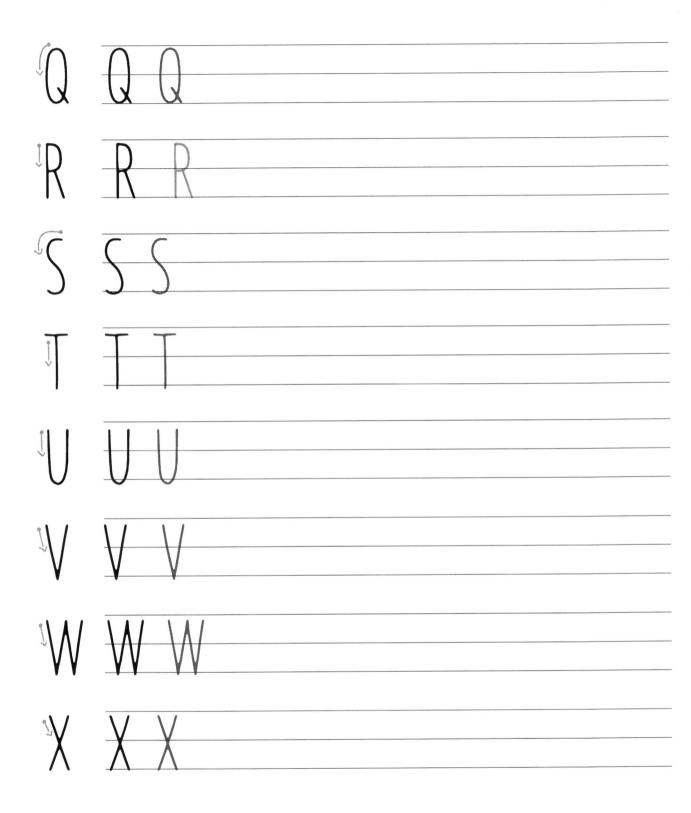

Q Q Q

R R R

S S S

T T T

U U U

V V V

W W W

X X X

Y Y Y

Z Z ZZ

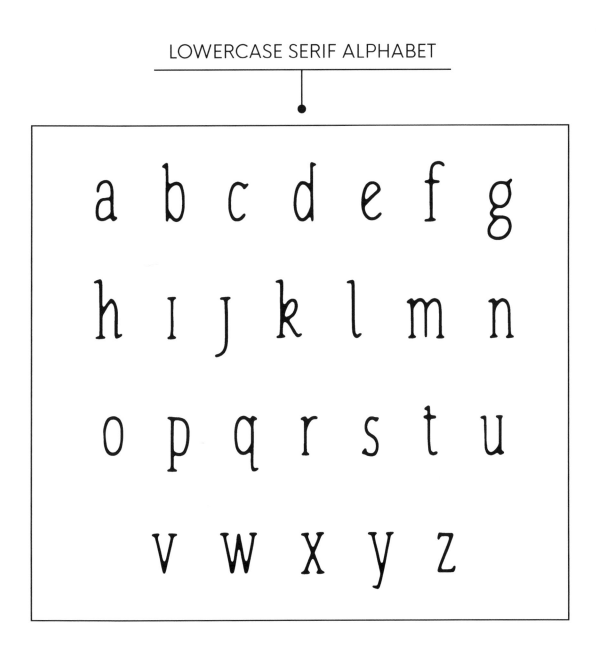

RAISE THE BAR!

This next alphabet introduces the "serif", or the little bars that rest at the end of each stroke! You'll notice that these little bars give the letter the perfect amount of flair to really raise the bar and make them a little fancier! When it comes to design, it's all in the details and a little bit goes a long way! How else can you add a little bit of flair to your letters?

You are amazing, friend!

I I I

J J J

k k k

l l l

m m m

n n n

o o o

p p p

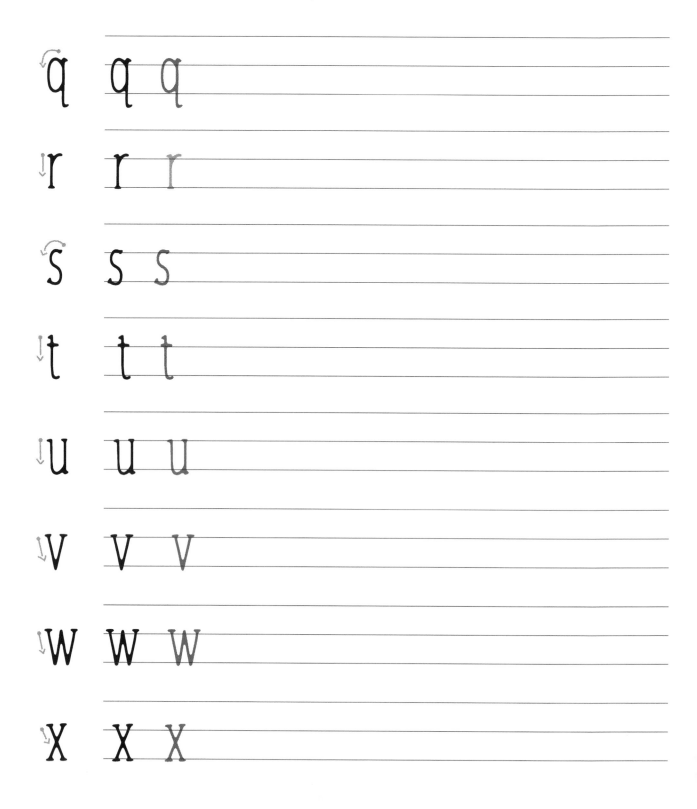

q q q

r r r

s s s

t t t

u u u

v v v

w w w

x x x

y y y

z z z

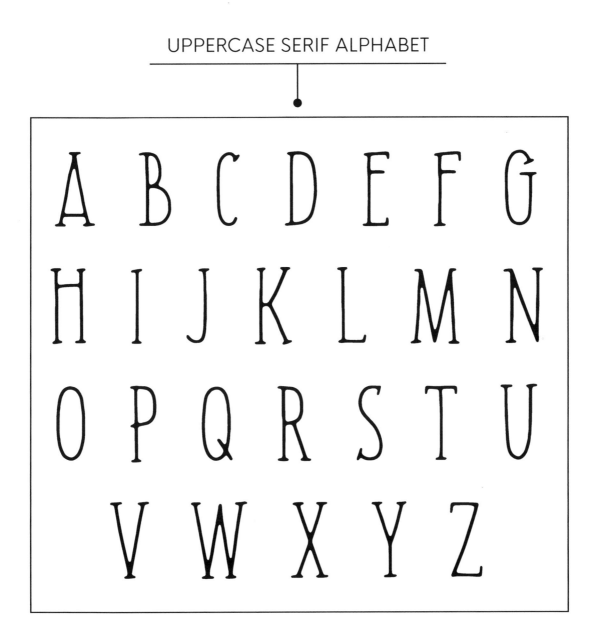

ONE LETTER TWO WAYS!

With this uppercase serif alphabet, let's look at another fun & easy way to differentiate your letters within the same "style". Let's take a look:

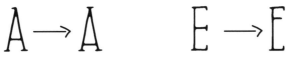

You can give a letter an entirely different feel just by playing with the placement of the cross bar with the letters "A", "E", "F", and "H". Try this out as you practice this next alphabet!

67

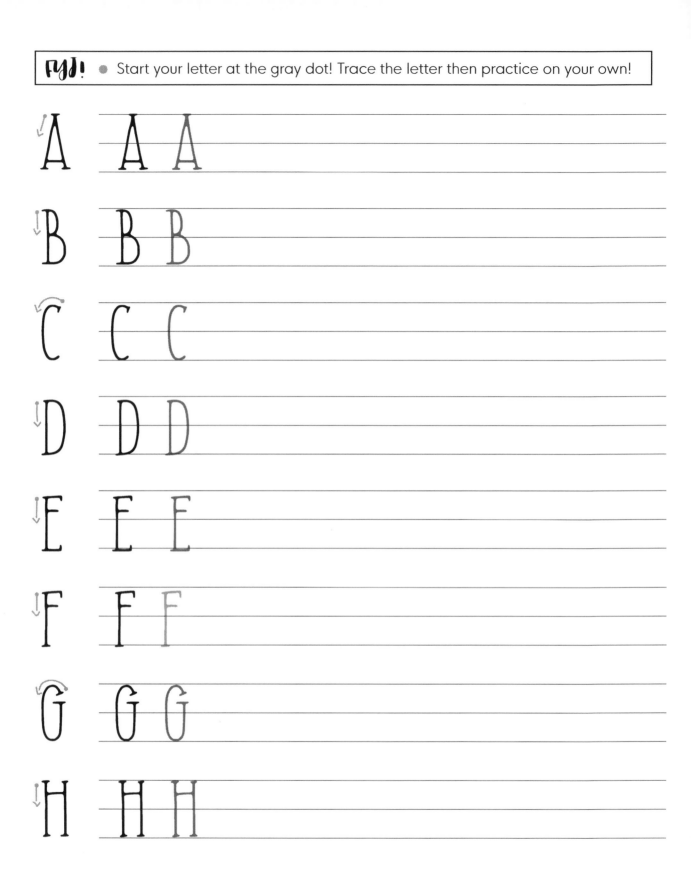

Those are some good lookin' letters right there!

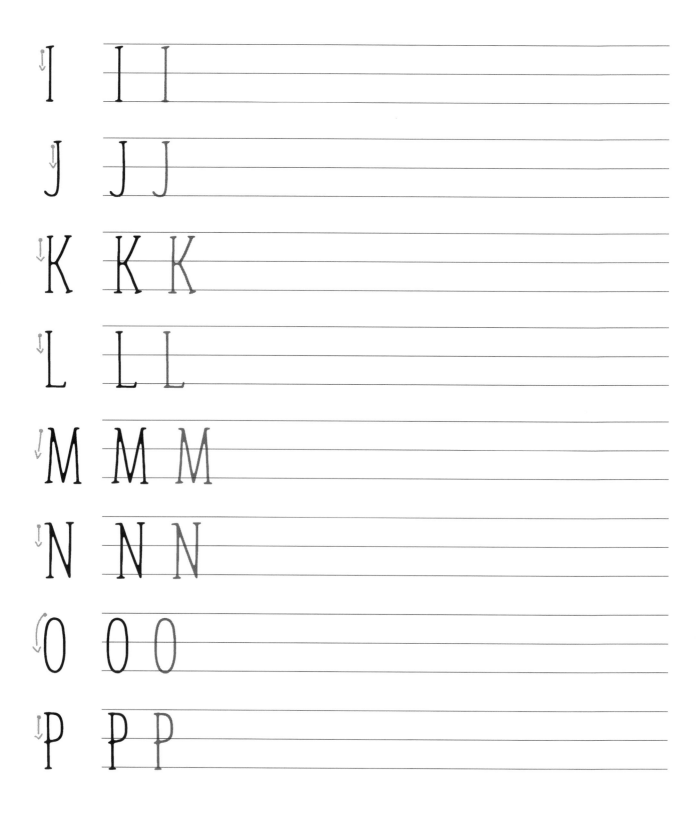

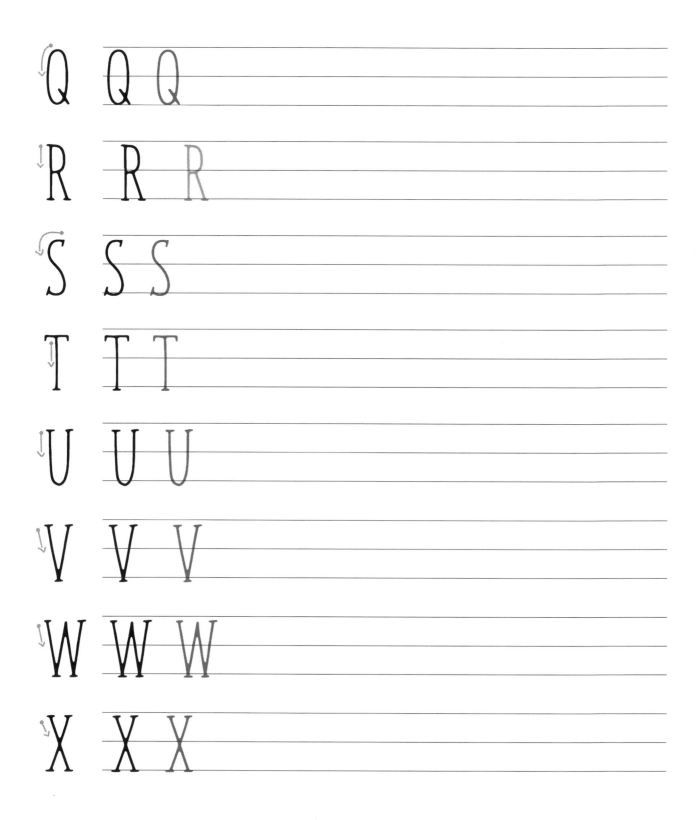

Y Y Y

Z Z Z

FUN SANS SERIF ALPHABET

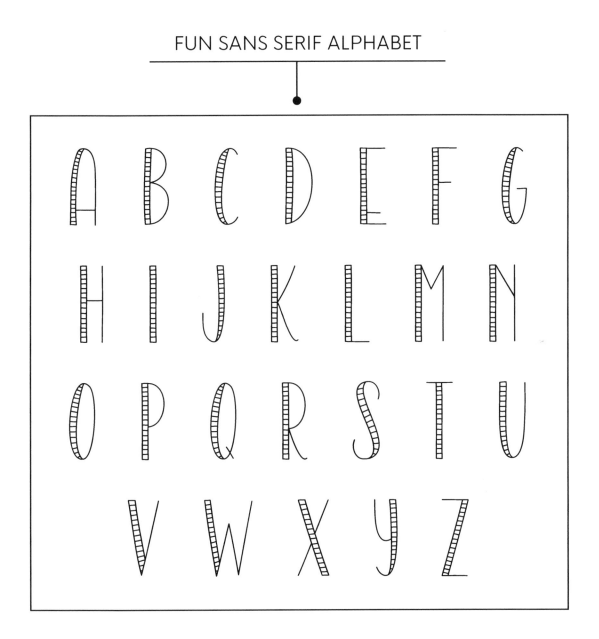

HAVE FUN WITH IT!

This last adorable alphabet is really just a reminder to have FUN with your lettering! Just like adding a serif can spruce up your letters, so can adding stripes, polka dots, or other doodles! You've made it through all of the practice alphabets so, clearly, you are a rockstar. Lettering comes with a lot of hard work and practice but it is supposed to be fun too!

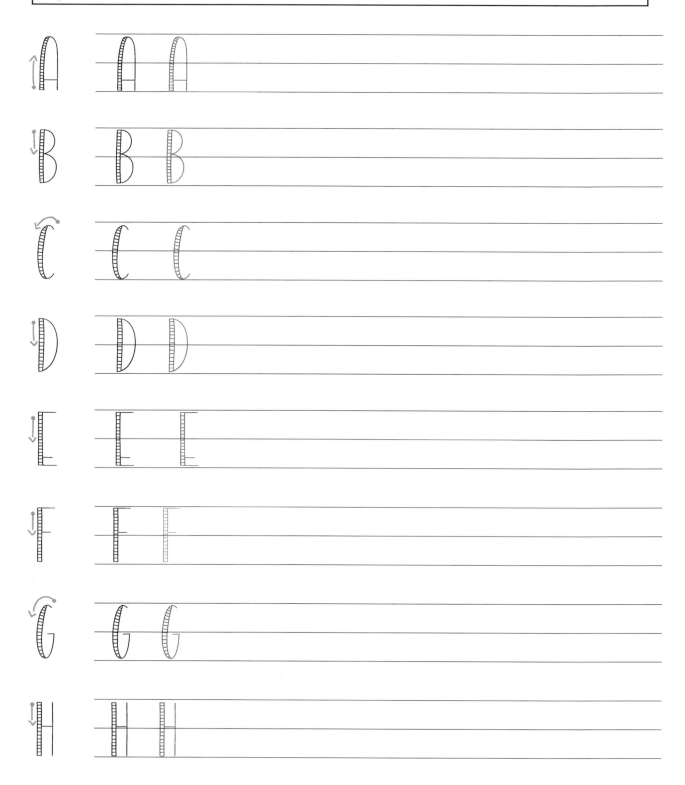

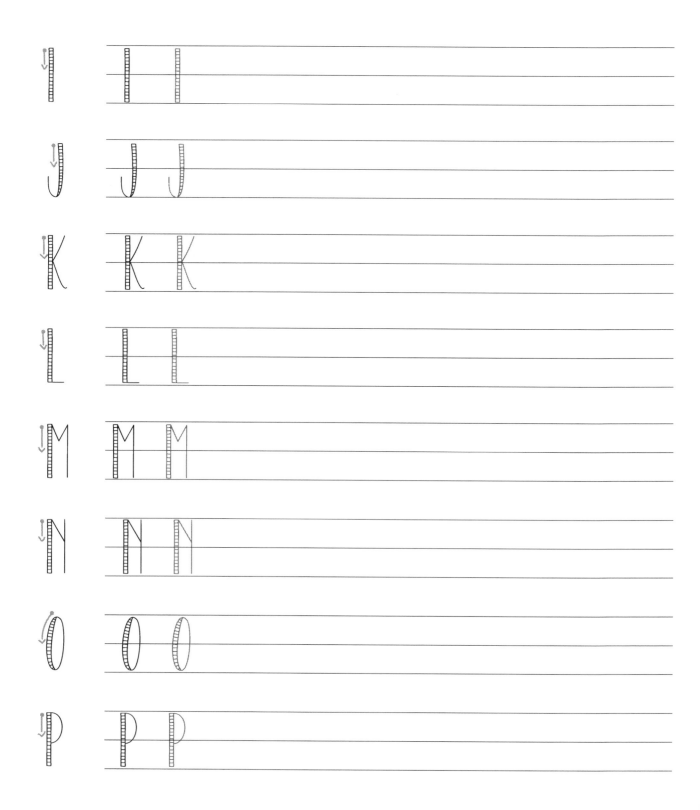

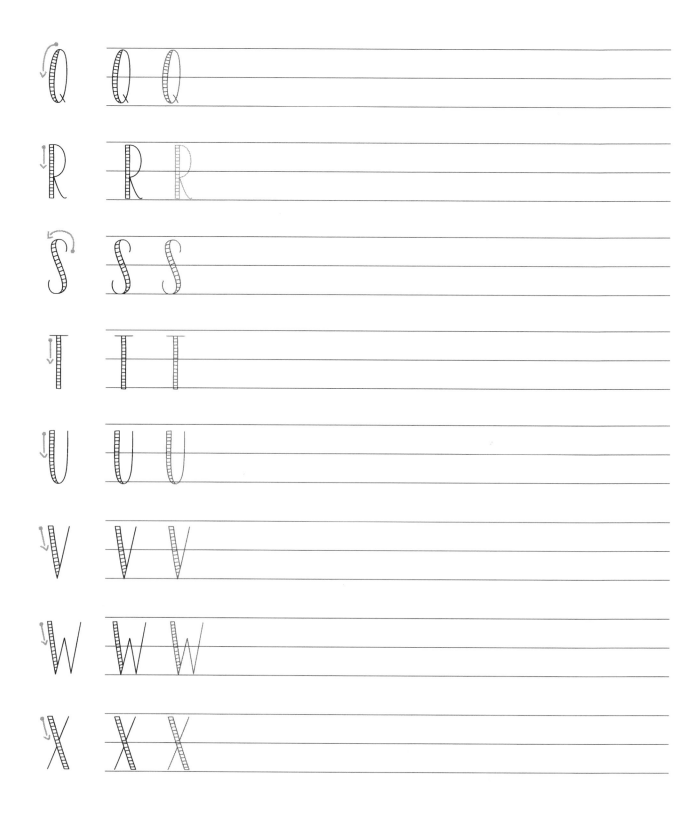

y y y

7 7 7

CONNECTIONS

Connecting Letters & Practice Words

CONNECTING THOSE LETTERS

The connector stroke is the last thin upstroke on every letter. These strokes play a very important role in the composition of your designs. The connectors not only add space between your letterforms to let your letters breath, they also help to convey the style of your design, whether it be whimsy, traditional, elegant, or playful.

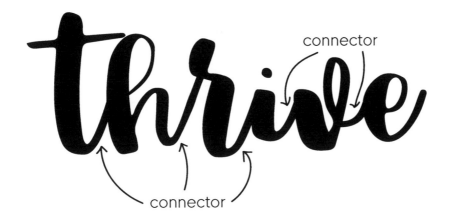

Connecting letters takes time and practice to master. You can write a word over and over with different connectors, larger ascenders, smaller descenders, and so on to create different lettering styles within each other. As you continue, you'll begin to develop your own style and you'll start to learn what you love and what makes your lettering stand out.

On the following pages we'll start with practice words as an intro to master the skill of connecting letters. Remember that It is important for you to first master your alphabets before you move to this phase. Practice, practice, practice, my friends, and you've got this! Grab your brush pen and let's get started...

hello *hello*

love *love*

sweet *sweet*

home *home*

cheers *cheers*

heart *heart*

bloom *bloom*

grow *grow*

spring

summer

fall

winter

lovely *lovely*

party *party*

congrats

invited *invited*

coffee coffee

wine wine

donut donut

tacos tacos

treats treats

happy happy

weekend weekend

hooray hooray

favorite *favorite*

beautiful *beautiful*

awesome *awesome*

grateful *grateful*

forever *forever*

darling *darling*

blessed *blessed*

flourish *flourish*

PROJECT DESIGN

Composition, Design, & Projects

COMPOSITION & DESIGN

Now that you've mastered your letterforms and connecting letters, it's on to the fun part – the design and composition of your lettering pieces! Let's break this down...

■ MIXING LETTERING STYLES

When selecting lettering styles, it really depends on the meaning behind what you are writing and what feeling you are trying to convey. For example, let's look at how serif and sans serif fonts are generally viewed:

SERIF

traditional
authoritative
classic

SANS SERIF

modern
clean
casual

As you begin to mix and match you'll develop favorite combinations!

■ COMPOSITION

The number one thing to keep in mind when creating a design is BALANCE. Every word and every letter can be a different size and have a different flourish, however, it must be laid out in such a manner that in the end everything is balanced. Here are a few tips to help:

1) Always start your sketch with pencil first.

2) Decide what words are most important in the phrase or what words you want to stand out. These words should be the biggest on the page and you should draw them first.

3) Now you want to fill in your space with the rest of the smaller words. This is where you have to work to maintain that balance. Don't be afraid to erase! Most artists don't get it perfect on the first try.

4) Add flourishes and decorative elements to finalize the balance and really polish the piece!

On the next page we'll look at the breakdown of a design and then dive into creating some easy projects! (HOORAY!)

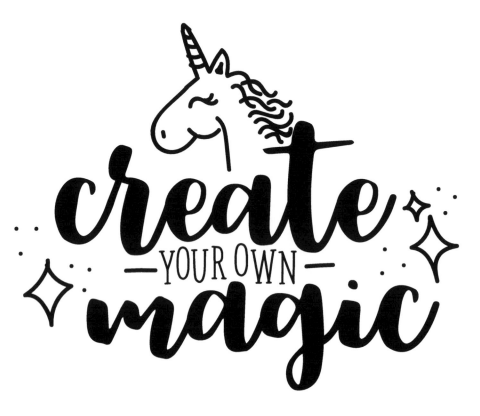

1. The words "create" and "magic" are the most important words so they were drawn first and the biggest to make them stand out.

2. I filled in the words "your own" and had to tinker around with placement and size to make it work.

3. I added a unicorn doodle on the top to make it fun and bring a bit more visual interest. Who doesn't love a good unicorn?!

4. After I added the unicorn, the sides were looking a little bare so I added in a few sparkles to help bring some balance to those areas.

things to note!

Developing an eye for design and creating balance in your pieces will come with time! The more you create the more you will grow to learn what looks good and what you love!

you Rock

1. I started with the word "rock" but since there are only two words, one word doesn't hold a lot of dominance over the other in this particular phrase.

2. The first time I wrote "rock" I actually just made the "k" a normal "k".

3. I started writing "you" and decided to have the "y" connect with the "r" to make the phrase flow together and look more custom.

4. After I finished writing "you" there was too much blank space in the top right, so I erased the basic "k" and added a big, fun flourish to help fill in the space.

things to note!

You don't always have to add illustrations to complete a design. Sometimes just adding a few simple flourishes can really polish a piece!

·HIP·HIP·
HOORAY!

handmade WITH love

PRACTICE

PRACTICE

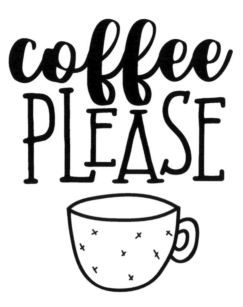

PRACTICE

Bloom WHERE·YOU·ARE·

PRACTICE

PRACTICE

PRACTICE

PRACTICE

PRACTICE

PRACTICE

—— DELIVER TO: ——

the witherspoon family

123 WALLABY WAY
CHICAGO, IL
6 · 0 · 6 · 1 · 0

PRACTICE

PRACTICE

Printed in Poland
by Amazon Fulfillment
Poland Sp. z o.o., Wrocław